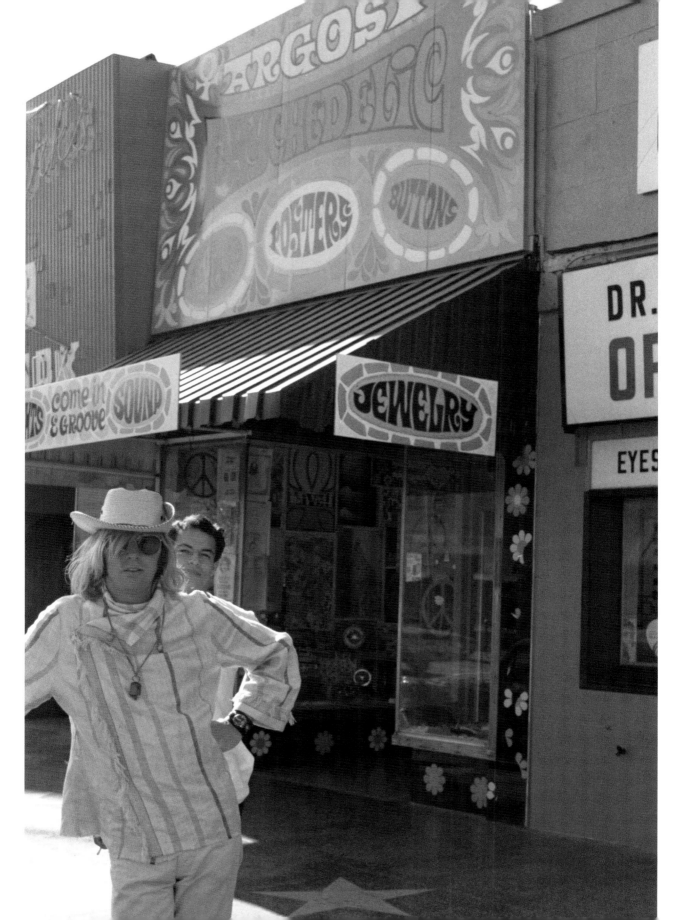

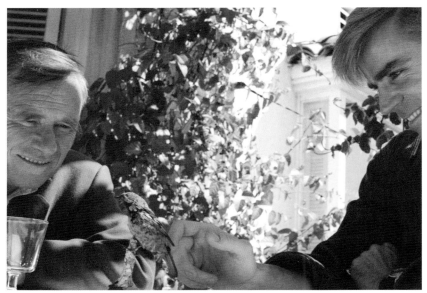

CHRISTOPHER ISHERWOOD AND DON BACHARDY, SANTA MONICA, 1968.

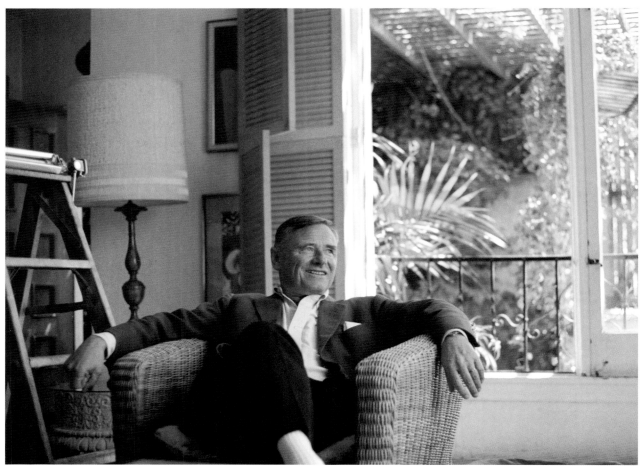

CHRISTOPHER ISHERWOOD, SANTA MONICA, 1968.

JACK LARSON AND JAMES BRIDGES, LOS ANGELES, 1968.

My horizon quickly expanded as I was introduced to David Hockney's large circle of friends. The poet Jack Larson, who wrote librettos for Virgil Thomson, had played Jimmy Olsen in the *Superman* TV series, and he lived with James Bridges, the movie director, in a diminutive Frank Lloyd Wright house in Los Angeles, which they had rescued from orange linoleum and a leaking roof. Christopher Isherwood and Don Bachardy were neighbors of ours who lived in an art-filled, old Spanish house overlooking the Pacific. Christopher wrote in a book-lined study, and Don drew his portraits of movie stars in the garage-turned-studio. The six of us spent many hilarious evenings together, often at a little Japanese restaurant where they would sneak me sake, illicitly, as I was only eighteen.

JAMES BRIDGES, LOS ANGELES, 1968.

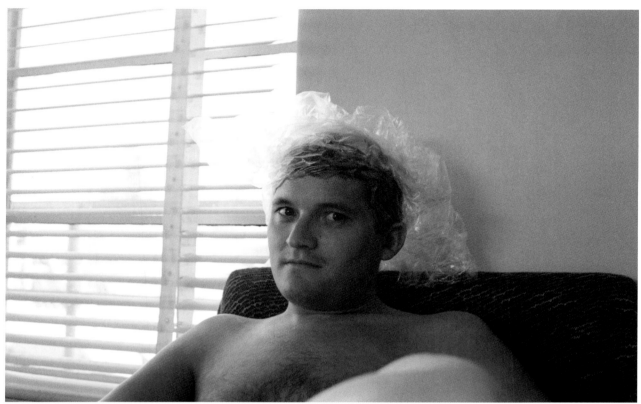

DAVID HOCKNEY, SANTA MONICA, 1968.

David Hockney's image and personality intrigued me. He represented a
world outside my own that I was eager to embrace, and we were soon
spending more and more time together, eventually becoming lovers.
After another semester at Santa Cruz, I transferred to UCLA to take art
full time and moved in with David in a run-down house in Santa Monica.

◄ OPPOSITE: DAVID HOCKNEY, SANTA MONICA, 1968.

*FRANCE,* 1968.

The summer of 1967, David Hockney and I toured Europe. This further convinced me that I was born on the wrong continent in the wrong century, and I had to persuade David that we should move to London so I could study painting at the gloomy old Slade School of Art. We agreed to go the following year.

Leaving America forever by air seemed unromantic, so I sailed from New York on the *France* in September. Even before leaving the dock, I happened upon Jim and Nancy Dine, whom I had met before, and we took our meals together in the Palm Court. I arrived in Southampton with everything I owned in one large trunk to begin my new life in gray and sniffly London.

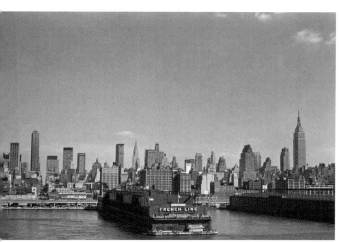

THE NEW YORK SKYLINE, 1968.

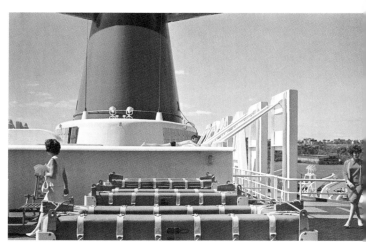

FRANCE, 1968.

ON BOARD THE FRANCE, 1968.

JIM DINE, 1968.

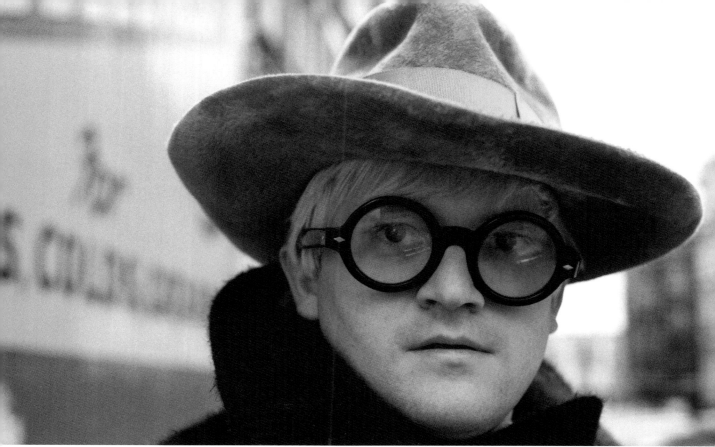

DAVID HOCKNEY, POWIS TERRACE, LONDON, 1968.

David Hockney had lived in his flat in Powis Terrace, in unfashionable Notting Hill, since he was a student. It was cheap and large, meandering through two houses. David's studio was a former bedroom and mine a room in his old friend Ann Upton's flat around the corner.

The streets were deserted of cars and looked quite depressed, but nearby was the bustling Portobello Road market, where I shopped for fruits and vegetables and old junk, which are now valuable antiques.

ME AS AN ART STUDENT, 1968.

OPPOSITE: DAVID HOCKNEY, POWIS TERRACE, LONDON, 1968. ➤

CELIA BIRTWELL, POWIS TERRACE, LONDON, 1968.

The textile designer Celia Birtwell was a close friend and a regular visitor to Powis Terrace. She designed printed textiles of great, almost innocent beauty, and she worked so closely with the fashion designer Ossie Clark that they married.

OPPOSITE: DAVID HOCKNEY IN HIS STUDIO, POWIS TERRACE, LONDON, 1969. ➤

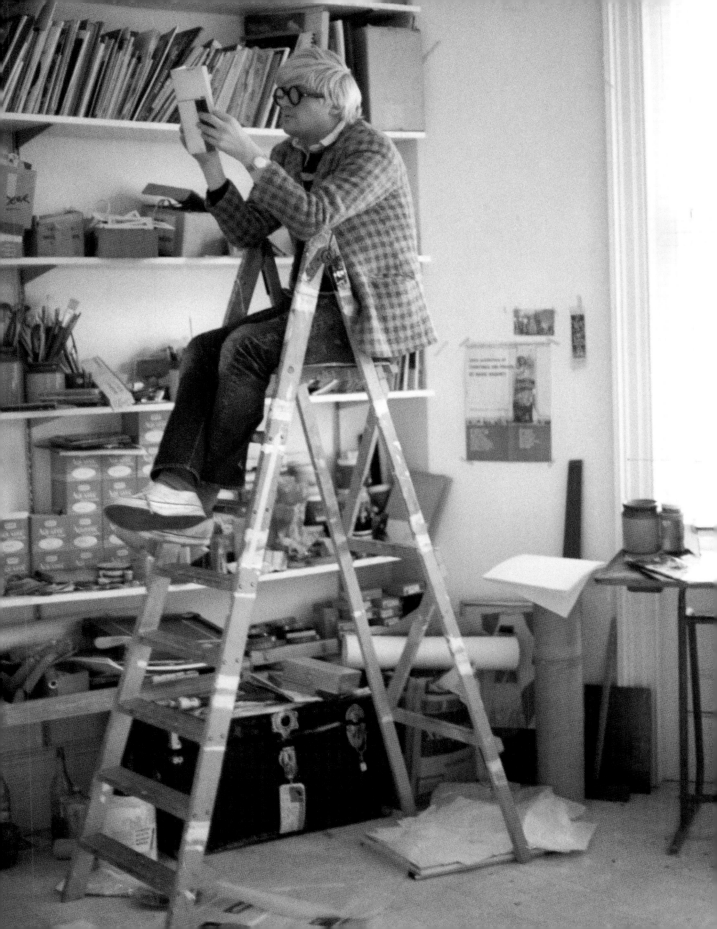

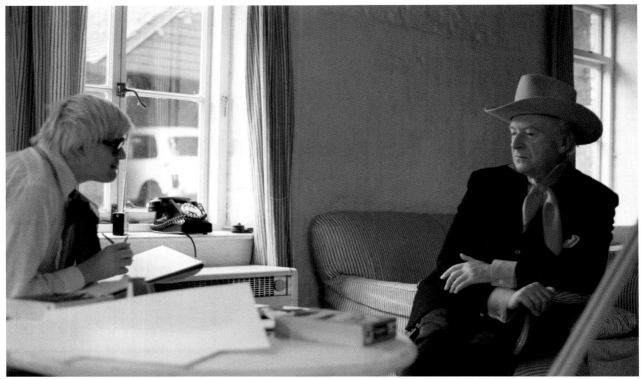

DAVID HOCKNEY DRAWING CECIL BEATON, REDDISH HOUSE, 1969.

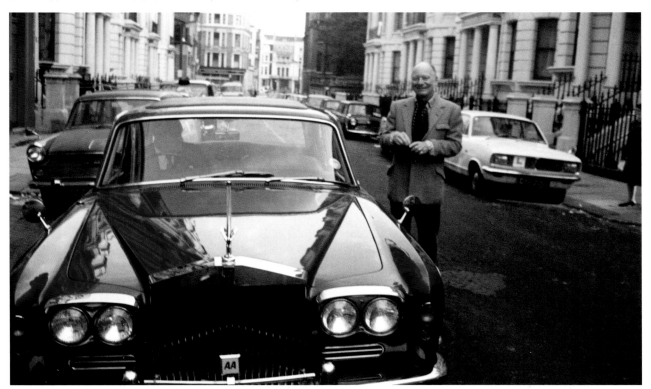

SIR JOHN GIELGUD, POWIS TERRACE, LONDON, 1969.

JOELY RICHARDSON, 1969.

NATASHA RICHARDSON, 1974.

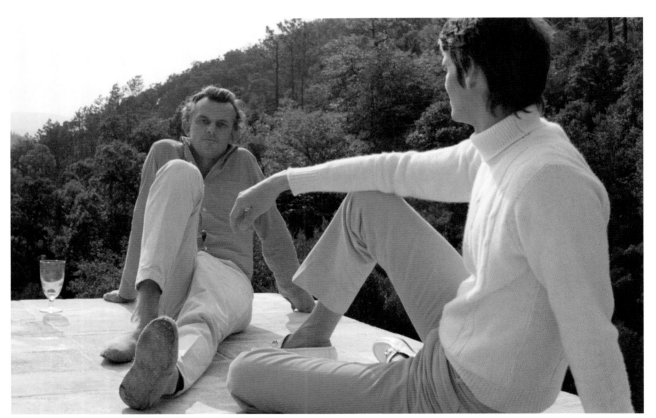

TONY RICHARDSON AND BILLY MCCARTY-COOPER, 1969.

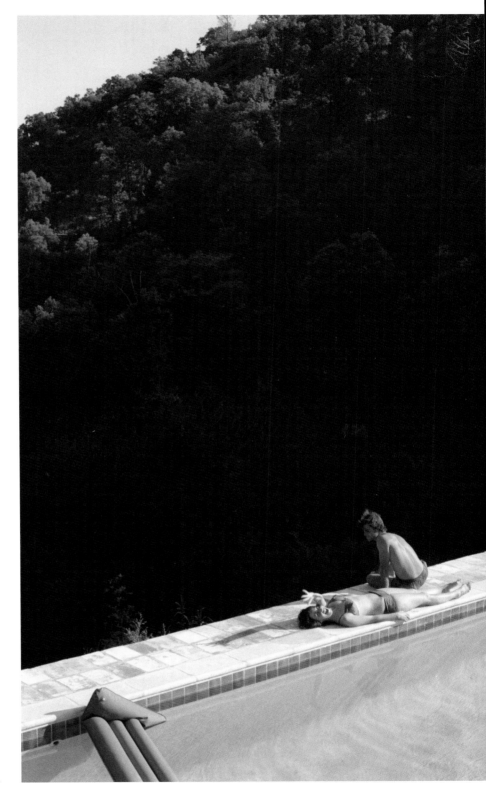

Le Nid du Duc was an abandoned little village in a quiet valley in the hills above Saint-Tropez. The great director Tony Richardson bought it and turned it with enormous flair into a magical compound of houses and guesthouses. It was always filled with friends, whether he was there or not. He could be cruel or incredibly charming, directing the house party as he would one of his plays or movies, and he loved guests who performed well. No extrovert, I failed the audition and he took a great dislike to me.

THE POOL, LE NID DU DUC, 1969.

OVERLEAF: PATRICK PROCTOR, LE NID DU DUC, SAINT-TROPEZ, 1968. ⅄

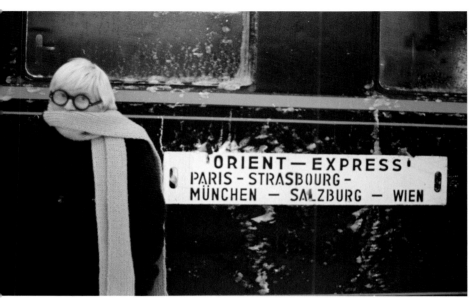

DAVID HOCKNEY, PARIS, 1969.

DAVID HOCKNEY, VIENNA, 1969.

The idea of the Grand Tour intrigued us, and we took many trips to the Continent—as the insular British call the rest of Europe—to visit museums or take the waters at the legendary spas. Karlovy Vary and Mariansky Lazne, the former Carlsbad and Marienbad, were then part of the Communist block, so the luxurious shopping arcades were shuttered and the once-grand restaurants were cafeterias for the proletariat. Yet their faded nineteenth-century glamour was hypnotic. Venice was another trip entirely.

OPPOSITE: DAVID HOCKNEY, VENICE, 1970. ➤

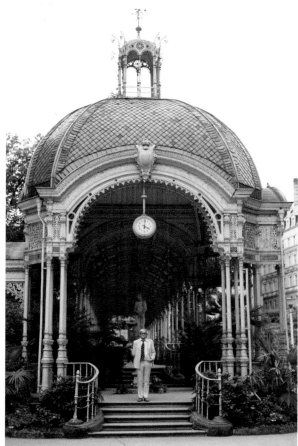

CARLSBAD, 1970.

The French spas were still grand and frequented only by the French. We stayed at the Pavillon Sevigne at Vichy many times, often with friends in tow.

DAVID HOCKNEY, PAVILLON SEVIGNE, VICHY, 1970.

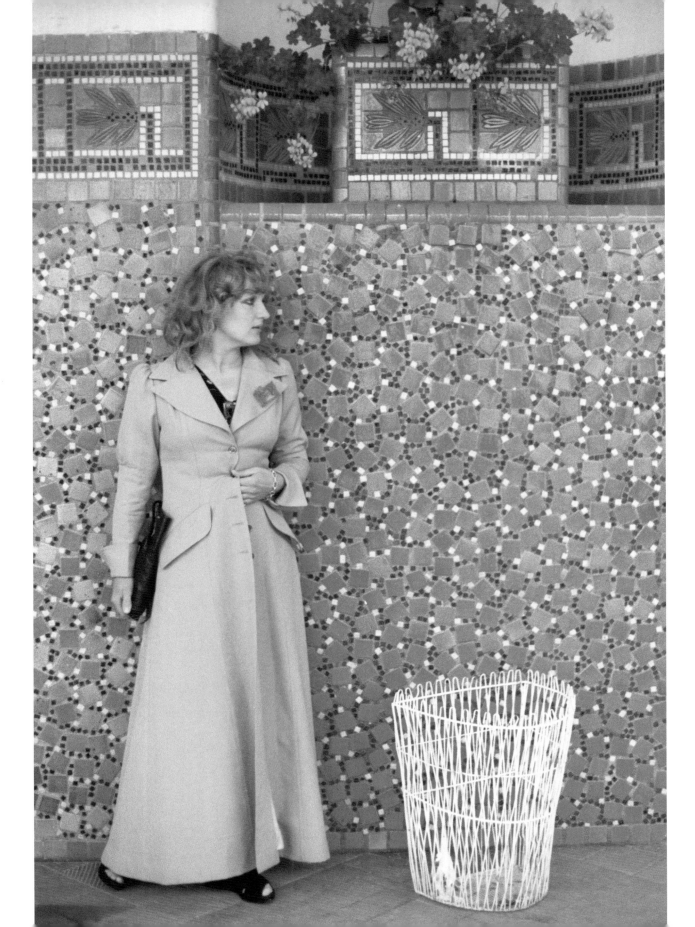

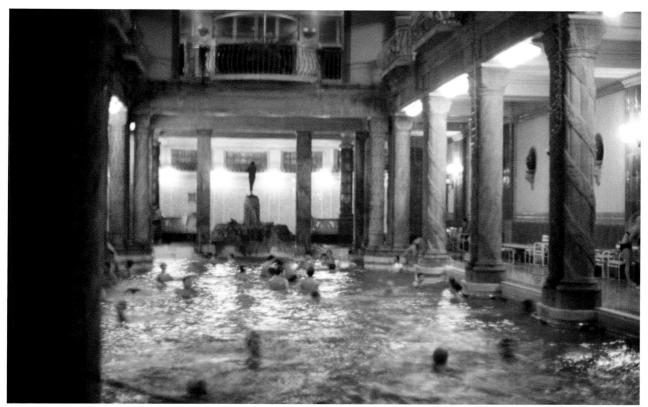

HOTEL GELLERT, BUDAPEST, 1970.

On one of these trips, we sailed down the Danube from Vienna to Belgrade, drinking homemade slivovitz with friendly Czechs and Slovaks, the only other tourists on the fairly seedy boat, and stopping in Budapest to see the mineral pool at the Hotel Gellert.

MARIENBAD, 1970.

◄ OPPOSITE: CELIA BIRTWELL, CONTREXEVILLE, 1970.

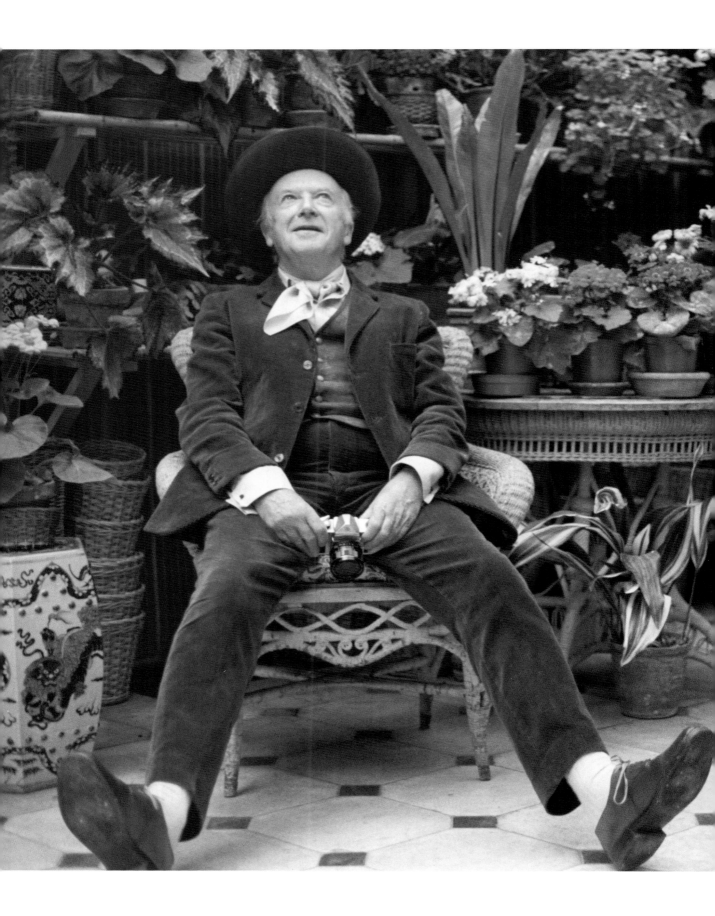

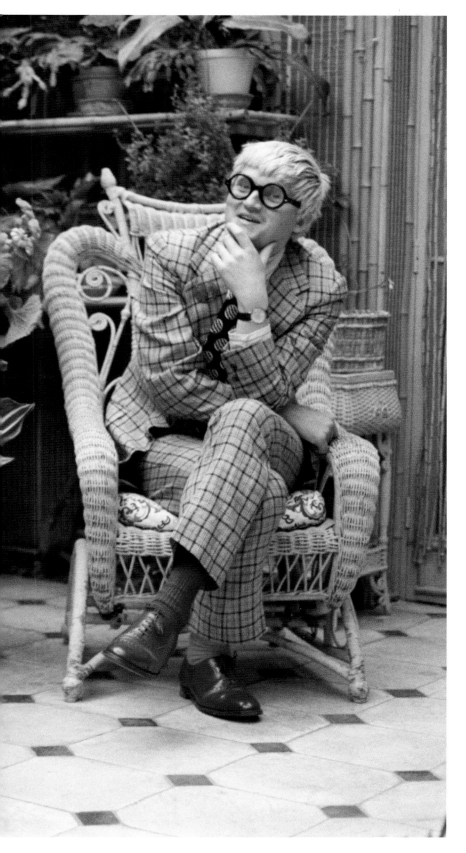

STILL LIFE, REDDISH HOUSE, 1970.

David Hockney and I spent many weekends at Cecil Beaton's country house in Wiltshire. It was called Reddish House and was partly real Edwardian and partly a theatrical creation of Cecil's. He had kept scrapbooks for years, which he let me look through, and they were an inspiration for my own albums. Cecil was an amusing, glamorous, and sharp-tongued dandy who in his diaries said, "the boys were well-behaved"—a great compliment.

DAVID HOCKNEY AND CECIL BEATON, REDDISH HOUSE, 1970.

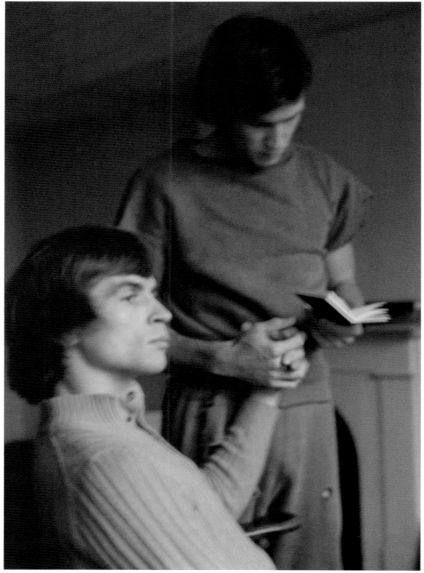

RUDOLF NUREYEV AND FILM DIRECTOR WALLACE POTTS, 1970.

Lindy Dufferin was a friend of Sir Frederick Ashton, and she took David Hockney and me to draw Rudolf Nureyev at the Royal Ballet rehearsal studios. Since the powers above wouldn't let me in the studios, I had to wait outside the door. There I met the dancer Wayne Sleep, and we immediately became the best of friends. Rudolf's house on the outskirts of London was filled with enormously overscaled furniture, "less likely to be stolen," he cannily explained with Russian peasant logic.

OPPOSITE: WAYNE SLEEP, PARIS, 1970. ➤

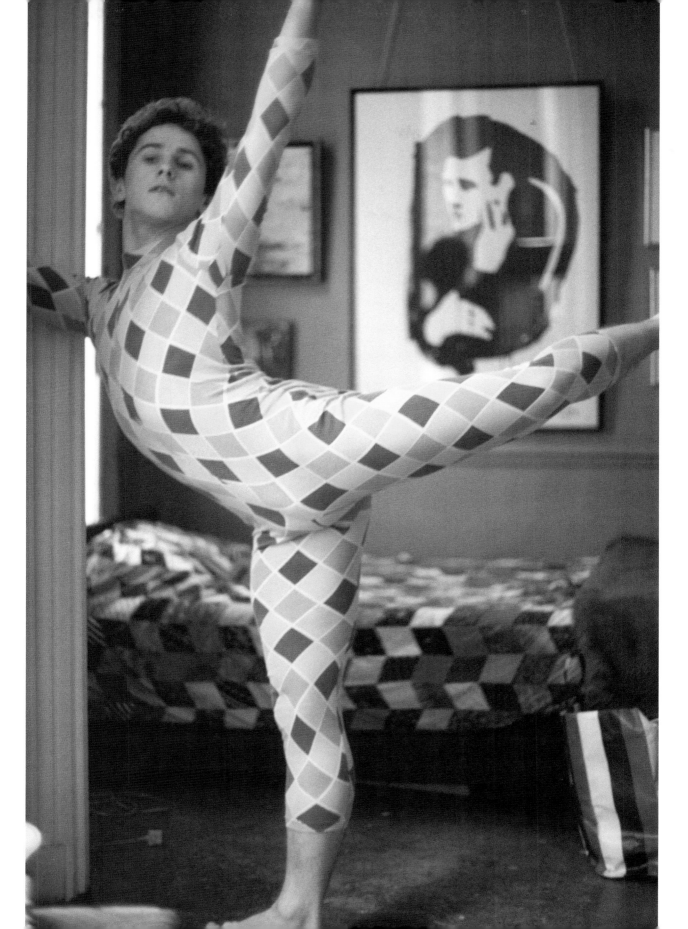

Wayne Sleep, a brilliant dancer with the Royal Ballet, is in the Guinness Book of World Records for doing more entrechats than Vaslav Nijinsky, and he would have been a romantic lead had the ballerinas not towered above him. He frequently let me watch rehearsals from backstage at the Royal Opera House, and also the filming of Sir Frederick Ashton's wonderful *Tales of Beatrix Potter*. In this romantic evocation of rural England, Wayne danced the role of Squirrel Nutkin. Sir Fred and character dancer Alexander Grant demonstrated rodent behavior for me and my camera.

WAYNE SLEEP, 1970.

44

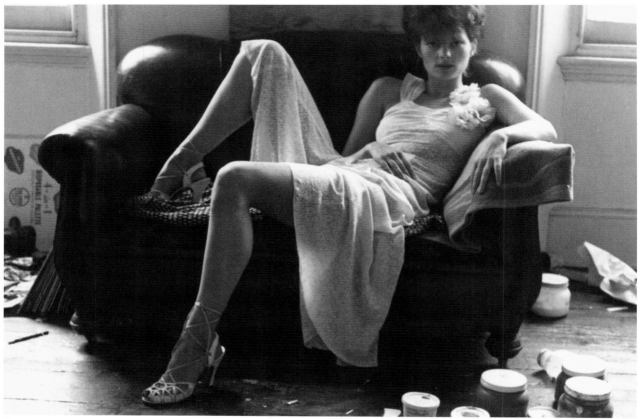

GALA MITCHELL, COLVILLE SQUARE, 1971.

The mysterious and eccentric Gala Mitchell was a cult model and favorite of Ossie Clark, designer Antony Price, and me. We became good friends and I painted her a number of times. One of the paintings looked quite a bit like the photograph of her on the couch, without the jars.

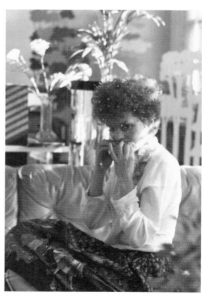

GALA MITCHELL, POWIS TERRACE, LONDON, 1971.

◄ OPPOSITE: GALA MITCHELL, COLVILLE TERRACE, 1970.

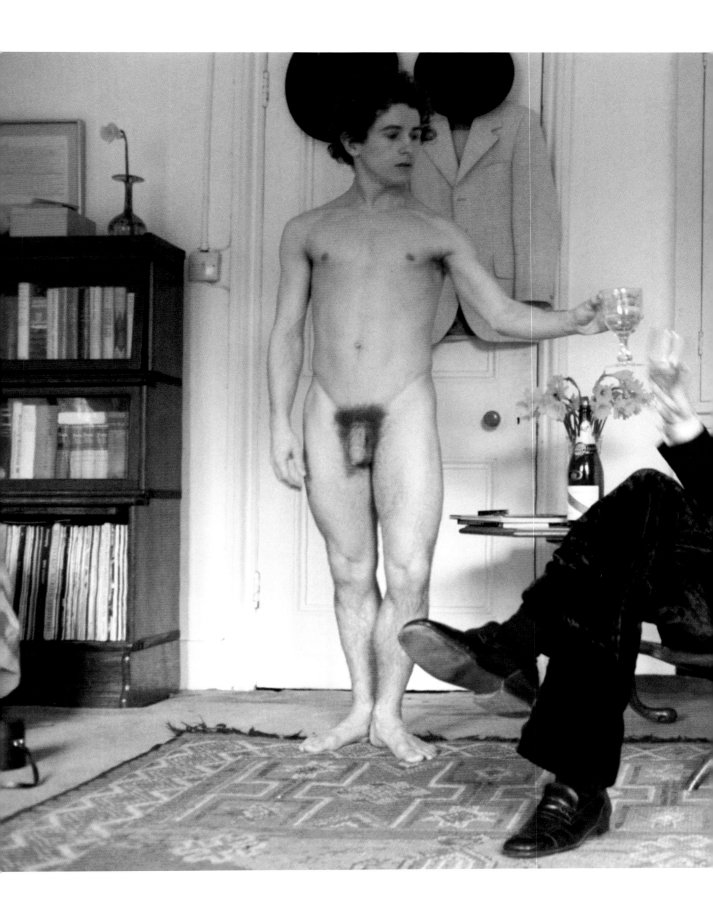

PALOMA PICASSO AND ERIC BOMAN, PARIS, 1971.

PALOMA PICASSO, PARIS, 1971.

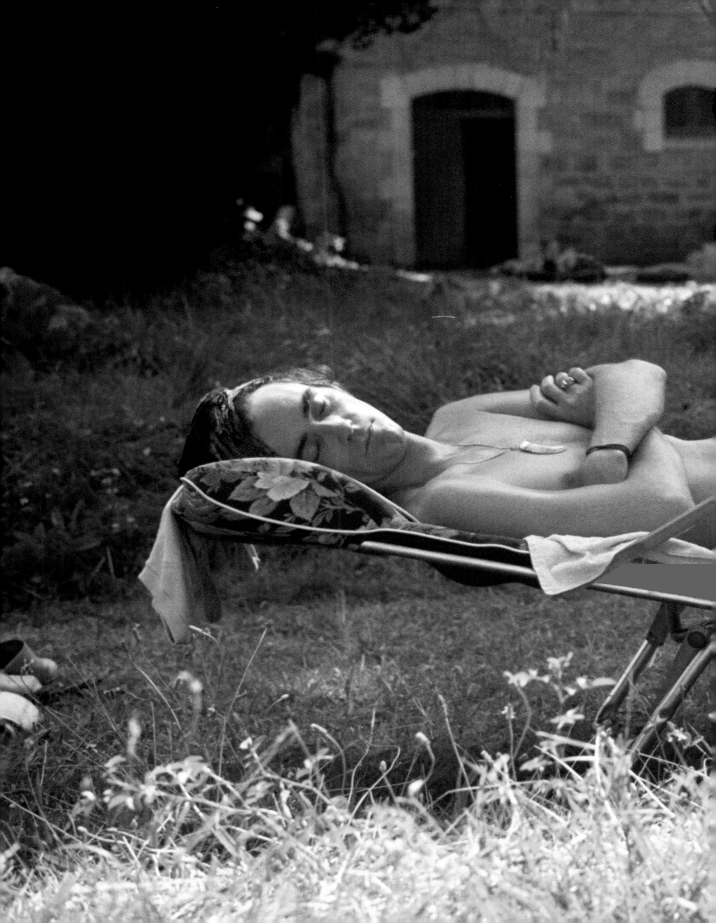

JULIAN LETHBRIDGE, PETER SCHLESINGER, CATHERINE GUINNESS, AND JASPER GUINNESS, CADAQUES, 1971. PHOTO BY ERIC BOMAN.

During the summer of 1971, the usual caravan of friends went to stay at the small Chateau de Carrenac in the Dordogne that Kasmin and his Francophile wife, Jane, rented. George Lawson and Wayne Sleep drove all the way from London in their open toylike car named "Noddy," arriving shaken and burnt to a crisp. David Hockney and I later went on to Barcelona and Cadaques, joining Mark Lancaster, Julian Lethbridge, and Eric Boman. Mark had rented Marcel Duchamp's old flat—where Duchamp had made *Bouche-Evier,* a lead sculpture cast from the sink plug—from his widow, Teeny. Other neighbors were Richard Hamilton and his girlfiend, Rita, and a houseful of Guinnesses. From there, I went with Catherine Guinness, Dom Hamilton, and Eric along the Riviera in Ossie Clark's Bentley Continental, the most beautiful car of all time, hoping to spend the night at Tony Richardson's. He would have none of it, so we went on to Ossie's pals Mick and Bianca Jagger near Cannes, where arriving at midnight we devoured an entire Paris-Brest pastry, meant for the next day's lunch.

DOM HAMILTON, BIOT, 1971.

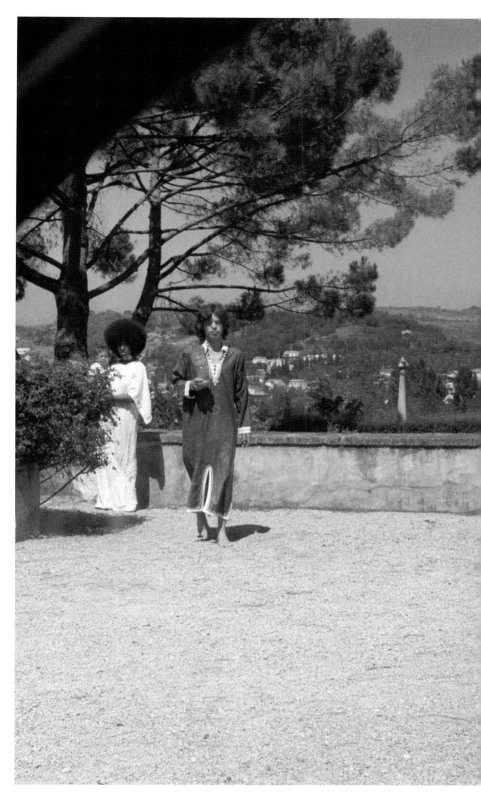

MICK JAGGER AND
MARSHA HUNT, BIOT, 1971.

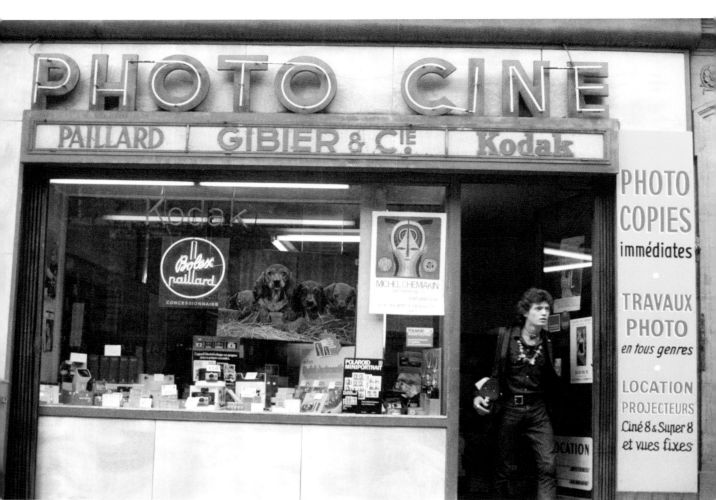

ROBERT MAPPLETHORPE, PARIS, 1971.

Composing a picture of a photographic shop on the Boulevard Saint-Germain, I noticed a handsome young man going in and pressed the shutter as he came out. Years later, in New York, a friend looked through my albums and recognized him as Robert Mapplethorpe, by then a famous photographer.

OPPOSITE, TOP TO BOTTOM: ST. CERE, FRANCE, 1971; LONDON, 1971; MUNICH, 1972. ➤

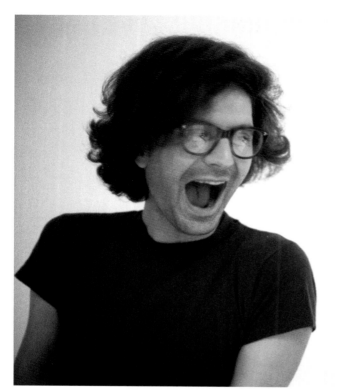
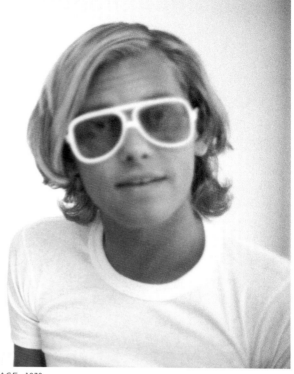

ABOVE AND BELOW: MANOLO BLAHNIK AND ERIC BOMAN, COLVILLE TERRACE, 1972.

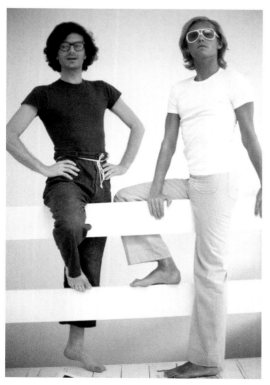

When I left David Hockney in 1971, I moved to a studio flat in a house in Colville Terrace. Manolo Blahnik moved into the top two floors of the same house a few months later. His place was all white and spare except for carefully placed furniture and objects, each one distinct in some way. Manolo, who had never cooked before, would make Canary

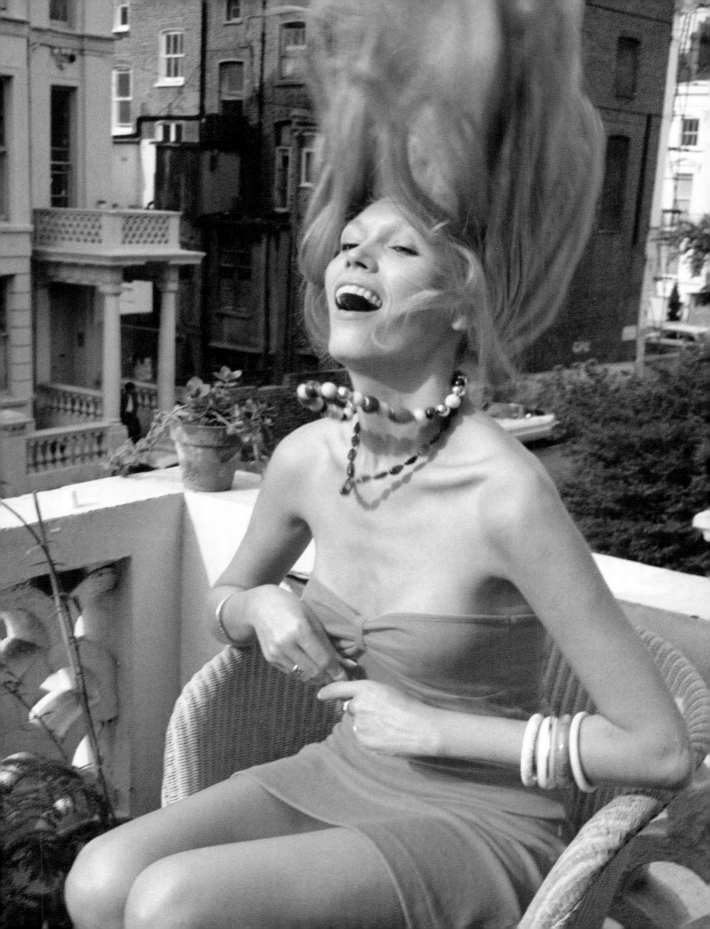

ERIC BOMAN, ULLA LARSON, AND JOAN JULIET BUCK, LONDON, 1973.

BIANCA JAGGER, LONDON, 1973.

Ossie Clark's fashion shows were glamorous spectacles that brought together fashion, art, and society. Amanda Lear, Gala Mitchell, and Beatle-wife Patti Boyd were runway fixtures. His first one was on a barge in Little Venice; others were held at the Chelsea Town Hall and the Royal Court Theatre. Usually late at night and never on time, they were fun and chaotic affairs.

◄ OPPOSITE: OSSIE CLARK, LONDON, 1973.

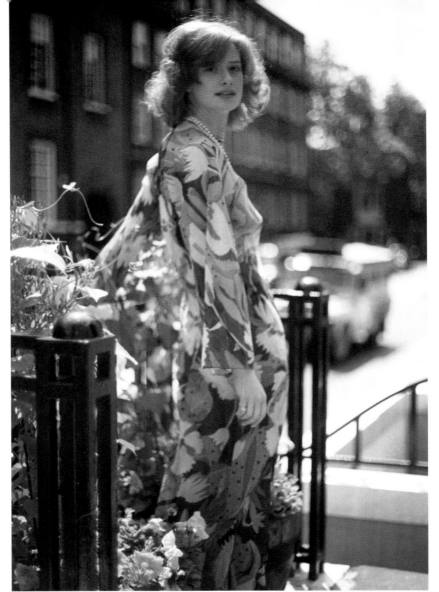

NICKY WEYMOUTH, LONDON, 1972.

Nicky Weymouth gave some of the liveliest parties in London, always lasting till dawn. She lived in the painter Augustus John's old studio in Chelsea, decorated by Christopher Gibbs in the "rich hippie style." Often without invitations or apparent planning, thirty people or more would show up. I usually went with Ossie Clark. In my painting of Nicky, she wore a dress he had designed in one of Celia Birtwell's most beautiful prints.

ISABEL STRACHEY AND VIOLET WYNDHAM, LONDON, 1973.

Violet Wyndham was the daughter of the writer Ada Leverson, whom Oscar Wilde nicknamed The Sphinx and who was his only friend when he left prison. Cecil Beaton said she wasn't half the man her mother had been, but I adored her. She lived around the corner from me in Notting Hill with her son Francis, a brilliant writer and critic. Her Portuguese cook, Maria, made delicious food for her own family downstairs while serving vile food for the likes of Princess Margaret, Roddy Llewellyn, Lady Diana Cooper, and the Jaggers upstairs. Isabel Strachey was a well-known novelist.

Violet Wyndham and I went many places together and made an odd couple of sorts. Once she invited me along to her friend Billy Whitaker's house for the weekend. Appropriately named Pylewell Park and inherited from his parents, it was unchanged since their day; his grown sister still lived upstairs in the nursery. The dessert peaches came from the hothouse, and the teacakes were fresh from the kitchen.

Cecil Beaton incorrectly but irresistibly called him Billy half-Whitaker. The other guests that weekend were Min Hogg, who hadn't yet founded *The World of Interiors,* and Spider Quennell, who had been married to the writer Peter Quennell.

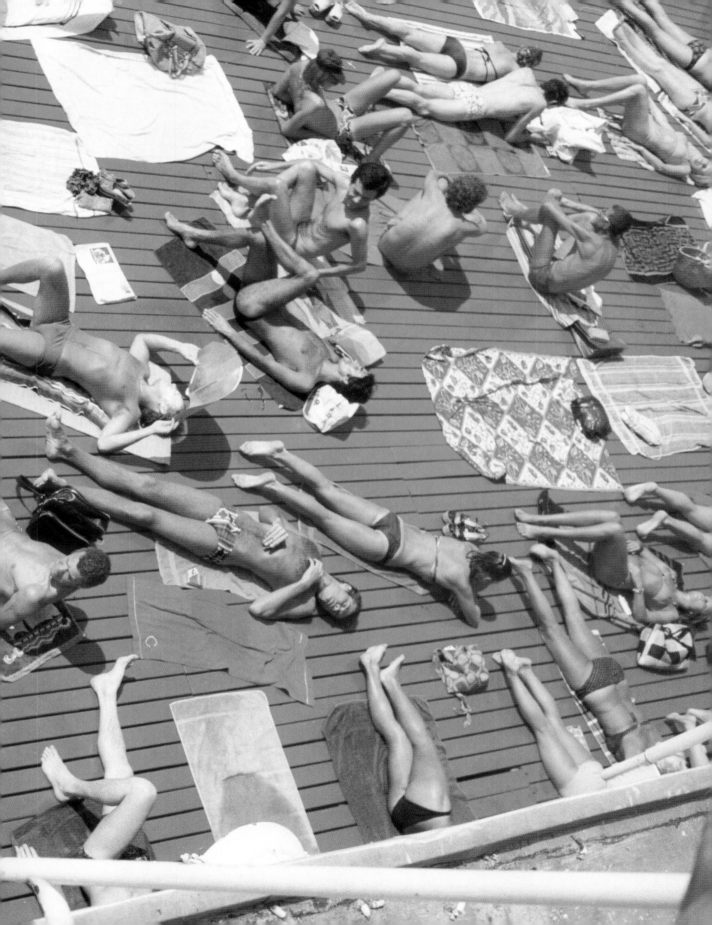

The Piscine Deligny, a nineteenth-century swimming pool that floated on the Seine and eventually sank, was a popular and cruisy people-watching and sunbathing spot where as little as legally possible was worn. An odd seasidelike presence in the middle of Paris, it provided an oasis on sizzling summer days and a challenge to the fashion-conscious to come up with new forms of exhibitionism. The woman eating ice cream came every day with different hair color and bikini to match. Jay Johnson was a model and part of the Warhol factory crowd. An infamous star and producer, Peter Berlin acted in his own pornographic films.

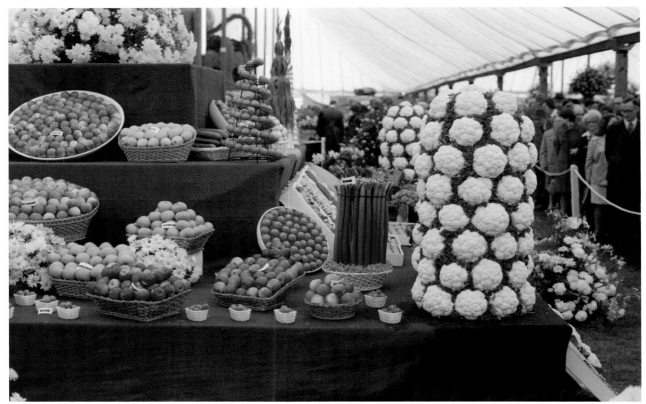

CHELSEA FLOWER SHOW, LONDON, 1977.

HARRODS, LONDON, 1976.

Everything English was what I loved and nothing was more English than the Chelsea Flower Show or the Food Halls at Harrods, where the star attraction was the artfully designed fish display, changed daily.

OVERLEAF: ERIC BOMAN, BATTERSEA, 1977.

MAUREEN'S LIPSTICK, LONDON, 1977.

Lindy and Sheridan, Marquess and Marchioness of Dufferin and Ava, gave lavish parties with an extraordinary mixture of people. They had a beautiful garden behind their house near Holland Park, and at one garden tea party (actually white wine), Sheridan's mother, the Dowager Marchioness, appeared. Maureen was a great character in London society since the thirties and forties and eccentrically stylish; one fabled dress was made of playing cards.

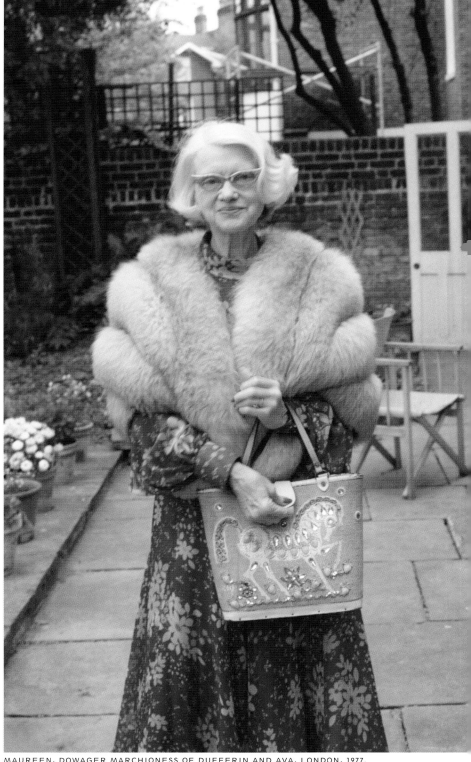

MAUREEN, DOWAGER MARCHIONESS OF DUFFERIN AND AVA, LONDON, 1977.

BARON PHILIPPE DE ROTHSCHILD, CHATEAU MOUTON, 1977.

David Hockney had been commissioned to design a wine label for Chateau Mouton-Rothschild. Wanting company for the trip to Chateau Mouton, he asked Celia Birtwell, who couldn't go, and I was recruited. How could I say no? Even hard-to-please Cecil Beaton said Baron Philippe de Rothschild was the most thoughtful and stylish of hosts. He was also kind and completely unsnobbish and served the most amazing food and, of course, incomparable wines of rare vintages, served in small quantities. His late wife Pauline's traditions were carried on, such as maintaining a special garden for growing her famous table decorations, and taking every meal in a different spot, as there was no dining room.

Joan Littlewood, the innovative stage director of *Oh! What a Lovely War,* was a neighbor and frequent guest.

LUNCH TABLE, CHATEAU MOUTON, 1977.

JOAN LITTLEWOOD, CHATEAU MOUTON, 1977.

BEDROOM, CHATEAU MOUTON, 1977.

SALON, CHATEAU MOUTON, 1977.

STEWART GRIMSHAW, WEST SUSSEX, 1977.

Of all the country houses I spent weekends at, Stewart Grimshaw's eighteenth-century house in West Sussex was where I went the most. Stewart loved chocolate, and violet creams were always on hand. One Easter he was the thrilled recipient of a giant chocolate egg.

ERIC BOMAN, SAINT-TROPEZ, 1978.

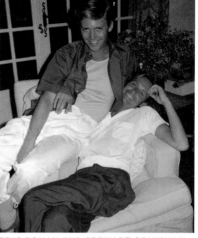

ERIC BOMAN AND STEWART GRIMSHAW,
SAINT-TROPEZ, 1976.

Stewart Grimshaw's house in Saint-Tropez overlooked the gulf and
Sainte-Maxime, where according to one houseguest "the slightly poor
people lived." His cook Dorine served the most delicious food. Regulars
included Tommy Nutter of Savile Row and Amanda Lear, who
pretended it was her house in press pictures.

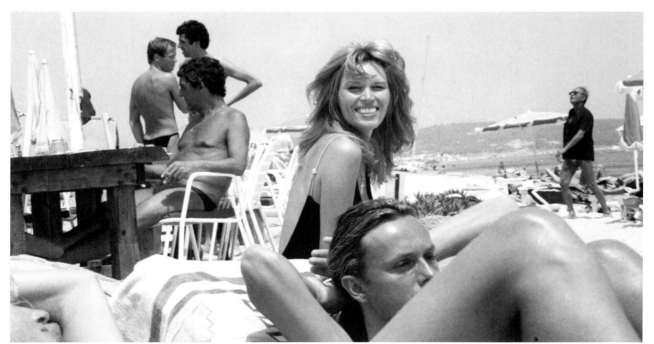

AMANDA LEAR AND STEWART GRIMSHAW, SAINT-TROPEZ, 1978.

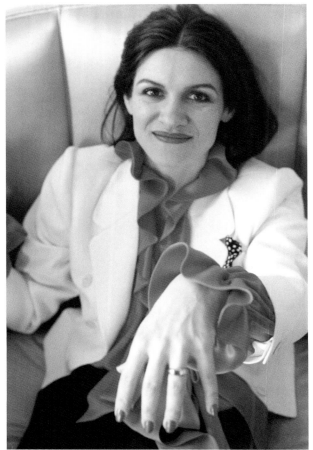

PALOMA PICASSO, PARIS, 1978.

MANOLO BLAHNIK, PARIS, 1978.

Paloma Picasso's wedding to Rafael Lopez-Sanchez lasted several days. The ceremony was presided over by a clerk with eyebrows painted on the middle of his forehead, which Paloma adored. Her admirer Yves Saint Laurent designed her white suit.

Manolo Blahnik threw Uncle Ben's rice, and Anna Piaggi, the Italian *Vogue* editor and legendary costume collector, appeared as a character from Proust reincarnated at the *Mairie du VIIe*.

ANNA PIAGGI, PARIS, 1978.

TINA CHOW, PARIS, 1978.

JACQUES DE BASCHER DE
BEAUMARCHAIS, PARIS, 1978.

ANNA PIAGGI, PARIS, 1978.

SALON, PARIS, 1978.

The celebration continued with a candlelit dinner at Karl Lagerfeld's eighteenth-century *hôtel particulier,* where a table filled an entire salon, barely allowing the waiters to squeeze by along the walls, and Anna Piaggi's plumed helmet caught dramatically on fire.

After the dinner, Paloma Picasso, in Lagerfeld, and Tina Chow, in vintage Mainbocher, refreshed their makeup in preparation for the dancing that followed.

OPPOSITE: PALOMA PICASSO AND TINA CHOW, PARIS, 1978. ➢

THE EARL OF DROGHEDA, 1978.

JESSICA DOUGLAS HOME AND HER
CHILDREN, 1978.

Peter Eyre suggested to his great friend Diana Phipps that she should invite Eric Boman and me to the coming-out ball of her daughter, where everyone had to dress as a character from an opera. Her American in-laws sent over from Old Westbury, Long Island, their flowered tent seating three hundred. Diana went as the Marschallin from *Der Rosenkavalier*. I went as Teresias from *Les Mamelles de Teresias*, and Gore Vidal thought I was Myra Breckinridge. Decorator Nicky Haslam caused a ruckus as a Nazi from his own fantasy opera, and Lady Diana Cooper wore the original costume from her 1931 stage appearance in *The Miracle*.

LADY DIANA COOPER, 1978.

JOHNNY GALLIER, 1978.

PAMELA HARLECH, 1978.

DIANA PHIPPS, 1978.

GORE VIDAL AND NICKY HASLAM, 1978.

MIN HOGG, 1978.

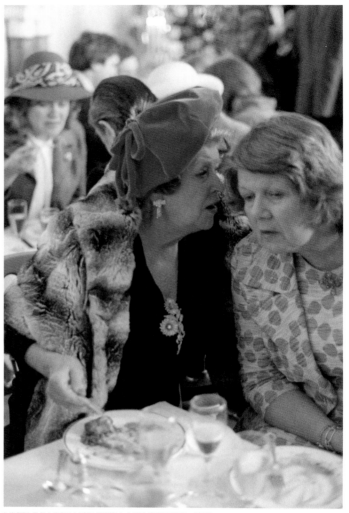

LADY BEAUCHAMP AND LADY COOPER, 1978.

Victoria Marten had met Eric Boman on Patmos, and they became close friends. She was lots of fun and deeply involved with teaching children. Soon after the stay in Greece, she went on a motorcycle trip to Scotland with a fellow schoolteacher, wearing Eric's motorcycle jacket and a twinkle in her eye.

Her mother, Maryanna, an old friend of Cecil Beaton's, had inherited a large eighteenth-century estate in Wiltshire and torn down